b12787498

779.092/HOR

KU-112-789

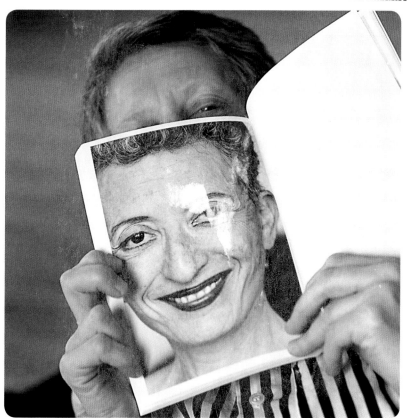

TU
DUBLIN

Donated to

**Visual Art Degree
Sherkin Island**

Australian Centre for Contemporary Art

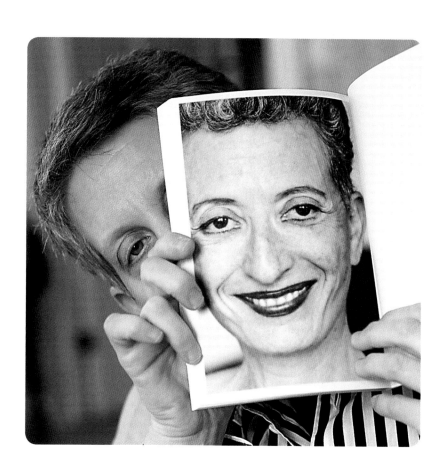

DIT Library Mountjoy Sq

You are the Weather 1995. A woman one-hundred times | **This is Me, This is You** 2000. A young girl identifying herself | **Cabinet of** 2001. A clown performing thirty-six expressions | **Index Cixous (Cix Pax)** 2005. Hélène Cixous defining language | **Portrait of an Image** 2005. Isabelle Huppert impersonating herself | **Weather Reports You** 2007. A collective self-portrait— talking about the weather

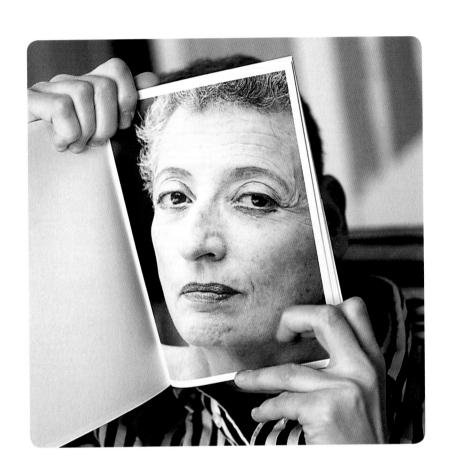

Portraits of Portraits
The Very Day/Light of Roni Horn

Hélène Cixous

These are not people, these are not things: what Roni Horn has meditated on, followed, observed, hunted, sketched, drawn, grasped cut up, edited, cited, are the figures of her secret questions, the oracular faces to which Roni Horn turns and returns in every way the question that haunts her: "Who are you, Face, you who I am, whom I follow, you who look at me without seeing me, you whom I see without knowing whome, you in whom I look at myself, you who would not be without me, you whom I envelope, you who seduce me and into whom I do not enter, who are you, who is this being promised subjected to my gaze, to my objective, this being docile to my law, and who remains totally impenetrable for me? What is you? Who am I, you?"

This. This This is Roni Horn. Roni Horn is this. This, speculation. She looks at herself in the mirror of another face. Face-seen by Roni Horn. What looks at her, touches her. She does not know why. She would like to know what affects her. Moves her genius.

Autoheteroportraits of Roni Horn, as Face.

These are not photographs, these are portraits of looks that don't allow themselves to be taken, snapshots of instants, series of winks of an eye.

These are series. The idea is not to add, it is not to correct, it is to assemble into a phrase the imperceptible events of appearances, the traces of a light, fleeting timeweather [*temps*], which are deposited on the surface of a face-figure. It is a system of writing, of recording phenomena which are produced in the contact between a living being and *temps*, as time and as weather.

Each series is a whole. Each whole collects a corpus around a singular subject-support, which was the object of a separate publication, signed Roni Horn.

But if you see Roni Horn's volumes, books, installations one after the other, you discover that each instalment is part of an ekphrasis, is a moment in a quest, the fragment of a whole whose face remains secret. From a certain moment on, all these figures, which were originally distinct, appear to be bathed in a sort of limpid water, a transparency which swathes in a single light the objects of Roni Horn's gaze, suspended in the very daylight of Roni Horn's anxious thought. Roni Horn thinks. She draws what she thinks, that she thinks.

As if all these portraits had been captured in the same (light of) day in the same season. This season is childhood. The time of insatiable curiosities. The mad desire to discover what is in the Cabinet. Who is, is not, there? There is a Cabinet, a container. The Content is enigmatic. We do not know what it is, what, who. We do not know what will happen, who is coming, what is contained. She does not know. This is what she paints: the enigmatic, the undecided. How can one paint the undecided?

Cabinet of: Portrait of the born-undecided [*l'indécis-né*]. Of the undrawn [*indessiné*].

To draw the undrawable.

Who? Whom? Whome? Youwho? I look: "you are the weather" or "This is me, this is you," that is "Portrait of an image", my shemblable my freer,[1] *Index Cixous*, if it's not you it's therefore[2]

your spectre, the hero of *Cabinet of*, brilliant book of nobody.

In the beginning there would be a waiting *Cabinet of*. Of? We are still waiting for the Messiah. *Cabinet of* is the portrait of the idea of the Messiah. We see the remains of the idea of the Messiah. There is no one here yet, except for the grimaces of an extraterrestrial given over to the passions. Sonogram of the emotions of a secret being. In the time of Genesis what is the weather [temps]? Mist of snow and blood. Prenatal anxiety. What will the Messiah's face look like?

We do not know him, he has neither name, nor contours, nor features. And yet we recognize the cries.

White cries, red cries. Photos of cries. She watches herself growing dreams of cries. In dreams the most heart-rending cries are drawn in white.

You are the Weather. Nothing is more idiomatic and more surprising than this address. *You are the Weather* plays between the singularity of the individual and the generality of the weather. What is more, the weather changes. Anything can happen. What characterizes the weather is that it is a series of events. The weather is itself by definition heterogeneous. The address *You* is undetermined. There is address, but who is You? God? The reader? The character? Emily Dickinson? Roni Horn? You? The person who plays the main role in this philosophical play?

The elusive strangeness of the character called Weather, calm to look at, a calm which by the name promises the storm. Weather lightly, calmly, androgynous, undecidable. Neither good nor bad, beyond. Very slight variations of pressure, of expressions. An intense passivity which lets happen. Lets and makes happen. A sort

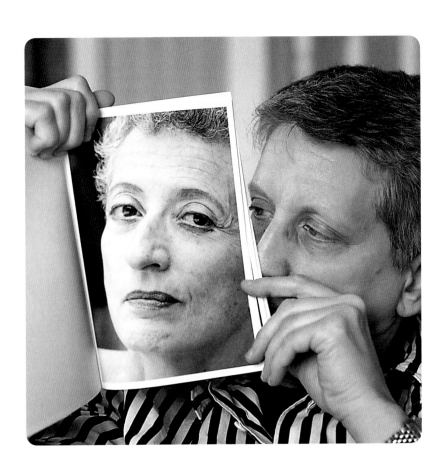

of authority without violence, which calls for and retains the gaze because this gentle authority looks at us. Without blinking, without seeing us.

The face: slightly enlarged. Treaded like an enlarged detail. The weather is our enlargement. The detail draws our attention to another detail.

It is a Pearl. Perhaps *You are the Weather* is addressed to her, the pearl. Or else perhaps it is the pearl who says to me: you are the weather. I am the calm. The agitation is her, Roni Horn, if it's not her, it's you.

This is thus the portrait of a pearl.

Pearl of pearl. The face with blue eyes.

Undecipherable on an opaque blue ground: pearl of Iceland. Thisland

Seen up close:

Pearl en abyme. Pearl on the right ear.

Aura of nearly pearl invisible at first glance.

To the right barely gilded pearl

Appearance-disappearance of the point of signature.

To the left on the neck, symmetrical pearl, beauty spot, "mole" Shakespeare would say, on Lucretia's breast, the only ornament, replies. The motif of the pearl returns, insists. Pearls of water on the nostrils, pearl rolls down a cheek. The perception of the reiterated pearl makes us think of a literary, analytic experience: the signature is hidden in the text.

Bit by bit this pearl calls up the memory of other pearls, transparencies, mixtures of light and opacities, spectre of the veil which makes the nudity of Rembrandt's Bathsheba.

The pearl is the only clothing of the "unknown woman" who is Weather's spokesperson. The unknown woman has no name, in the first place, like the Weather she speaks. No proper name? Until on a certain page we learn that her

33333 01187 9562 /779.092

name is Margrét, in reality. Margrét margaritas, margarites, in Greek, is the word for pearl. The Greeks knew the pearl by the intermediary of Alexander. The Pearl travels. The Unknown woman is the pearl itself.

At the end of the voyage we only see the damp sparkle of the original pearl.

How does one portrait engender another? Does she know the workings of this genealogy?

Portrait after portrait, portrait according to portrait, portrait of portrait, portrait of what has no features, at least in appearance, portrait of the weather, portrait of time, portrait of of , she continues her adventure, crossing through the child, the clown, which are awoken in her, called fascinated by these familiar strangers who come to her, by chance and necessity, who do not resemble her at all, except in this point of contact as small and defined as a pearl, where she recognizes a *je ne sais quoi* which touches her, for the flash of an instant: there! This is me! This I-don't-know-what which charms her, presents itself in disguise, as is always the case in love. By love she is guided. She draws what she loves, she loves what she portraits, but it is an artist's love. She desires collecting, not a person, a being, but the *je ne sais quoi* that moves her.

Let us not be mistaken, she does not do the portrait of Hélène Cixous or Isabelle Huppert. She captures the charm-pearl of unknown women, who speak to her under the names. Under the book in Hélène Cixous, under the image in Isabelle Huppert, this is what interests her: the emanation, the essential core, the tear of the secret, the je ne sais quoi, which makes the Face.

Portrait of an Image (with Isabelle Huppert) therefore deconstructs the entire traditional unthinking approach to the thing called Portrait, the use made of the word Portrait, when it is referred to people.

For this to happen the Portrait must personify the image. The difference between an image and a face: the face sees you. The image does not see you. Is seen. The gaze of the Portraitist gives a figure to the image.

If the image has a portrait, this is because it has eyes: the portrait eyes the image. Opens its eyes. And the image gives itself up to life. To reveal the portrait of the pearl hidden under the image, to allow one to hear the silent cry of the messiah locked in the Cabinet of

And afterwards?

She is always waiting for another of those absolutely singular, unforeseeable Yous who will come to respond to her cry:

Are you too one of my othermes?

Come! you co-me!

She paints everything in the plural. She paints the singular plural. The Face's – always more than one.

<hr />

[1] This is a citation from Finnegans Wake: Shaun describes his twin brother Shem in this way. "Shemblable" is a combination of the brother's name (Shem) and the French semblable, meaning "fellow creature," and "freer" is a play on the French frère, i.e. "brother." [Translator's note]

[2] This is a reference to the famous line in La Fontaine's fable "Le loup et l'agneau," "Si ce n'est toi c'est donc ton frère": "If it is not you it is therefore your brother." [Translator's note]

You are the Weather 1994-95. A woman one-hundred times.

Photographed in 1994 during a six week period of travel throughout Iceland using the geothermally heated outdoor pools as settings. | 100 photographs, (64 C prints and 36 gelatin-silver prints), 10 7/16 x 8 7/16 inches / 21.4 x 26.5 cm each. Installed as a continuous horizon on the four walls of a room. Seventeen sequences, six in black and white and eleven in color.

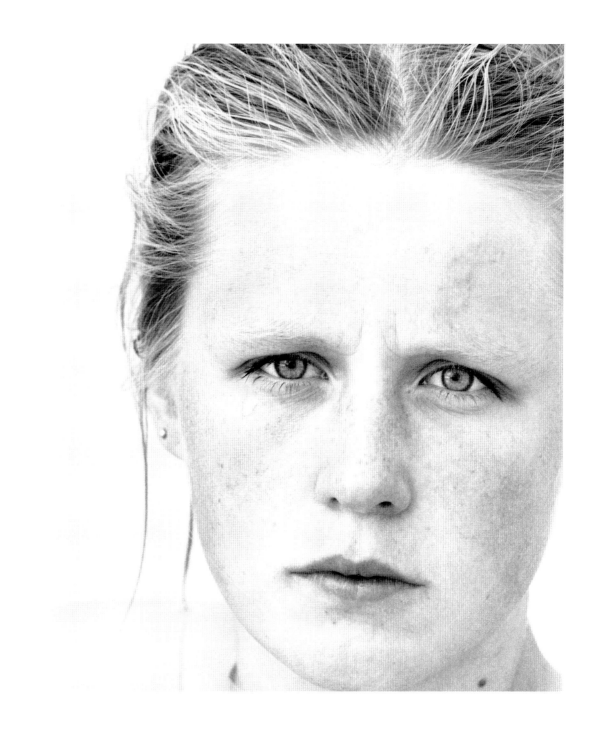

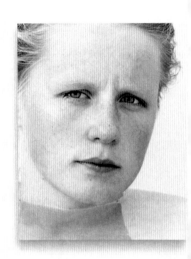

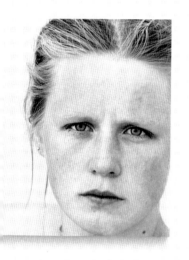 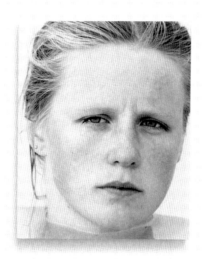 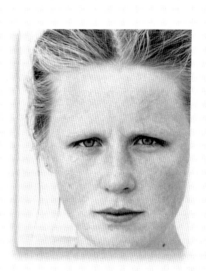

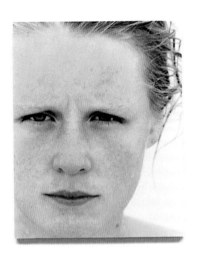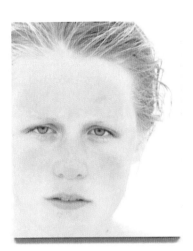

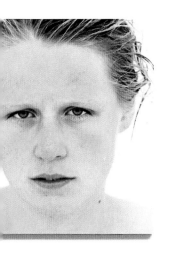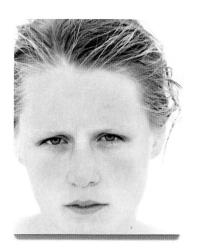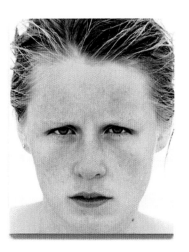

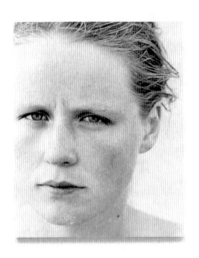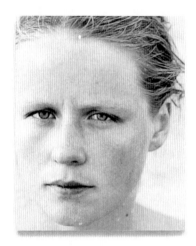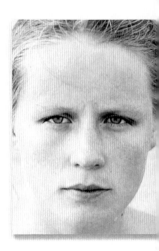

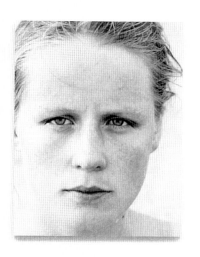 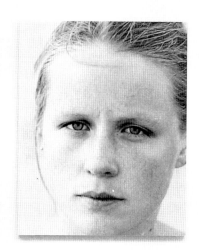 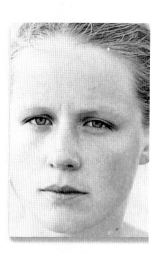

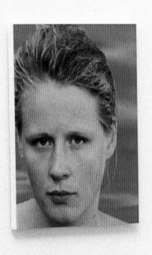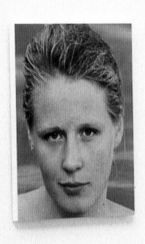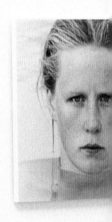

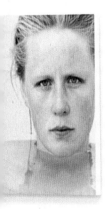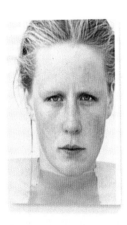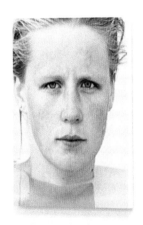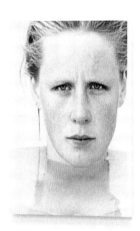

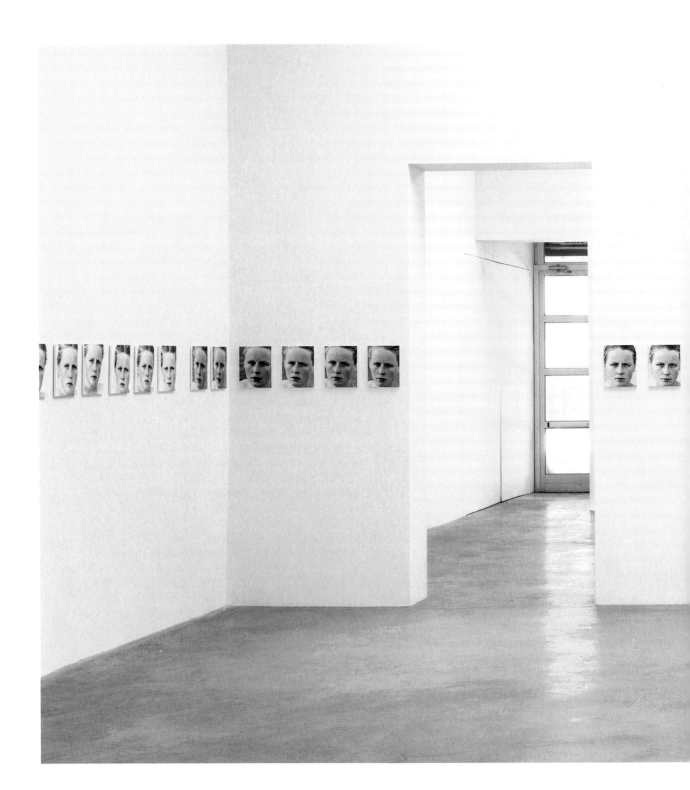

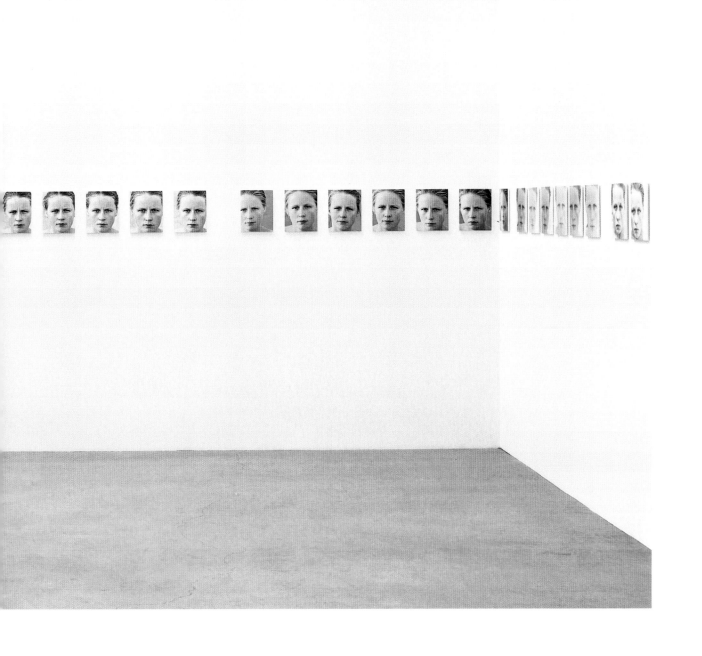

This is Me, This is You 1998-2000. A young girl identifying herself.

Photographed over a two year period (when Georgia was 8 to 10 years old) using a point-and-shoot camera. 48 pairs (96 photographs total) of framed C prints, each 10 1/4 x 12 1/2 inches / 26 x 32 cm. Displayed as two grids of 48 images each. The paired grids are installed on opposite walls or in separate rooms. Overall dimensions of each grid are 11 x 9 feet / 335 x 274 cm. | The book **This is Me, This is You**, 2002 is a uniquely bound twinned volume. 192 pages with 96 full color reproductions. 7 1/2 x 9 inches / 18.5 x 23 cm. Edition 7L, Göttingen, Germany.

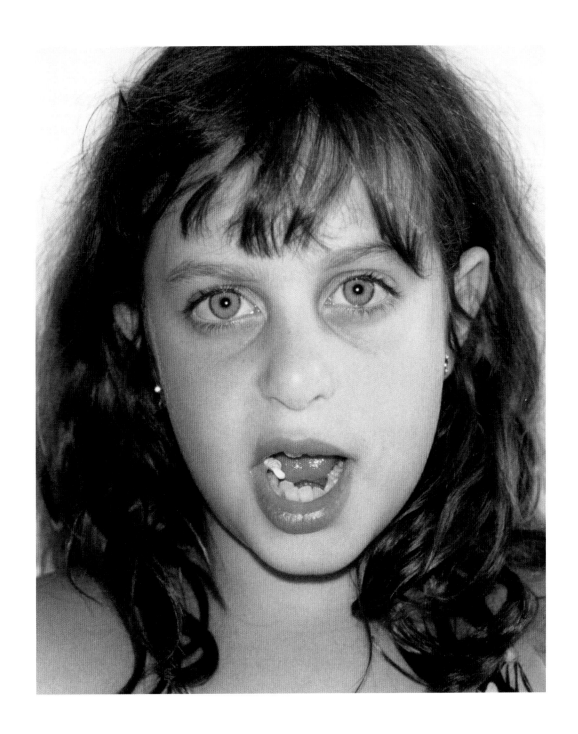

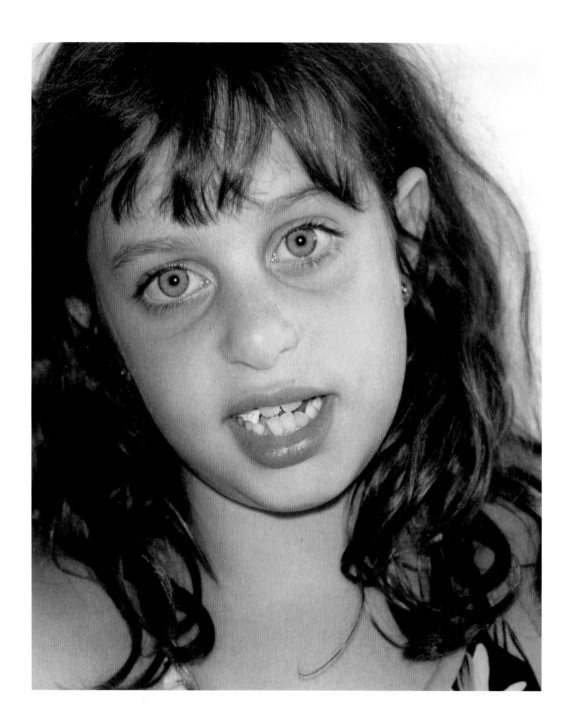

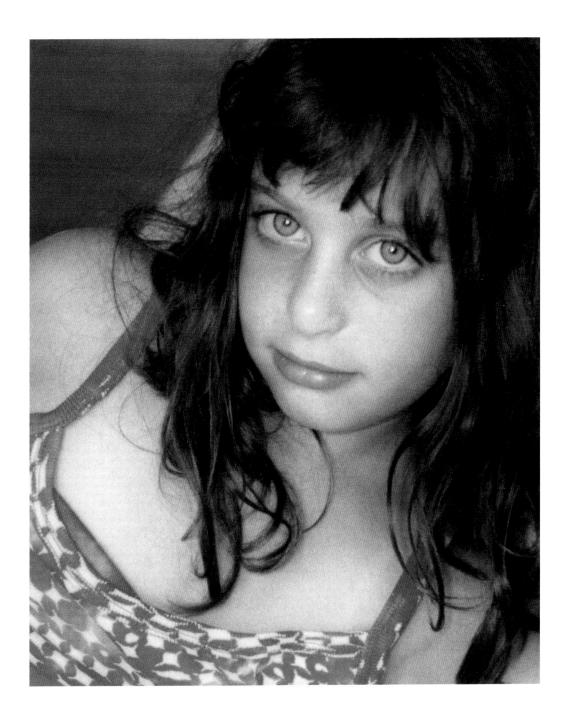

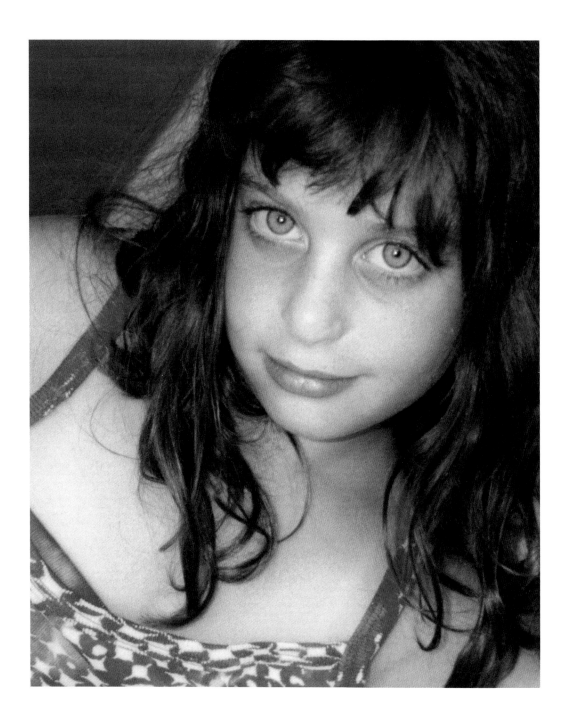

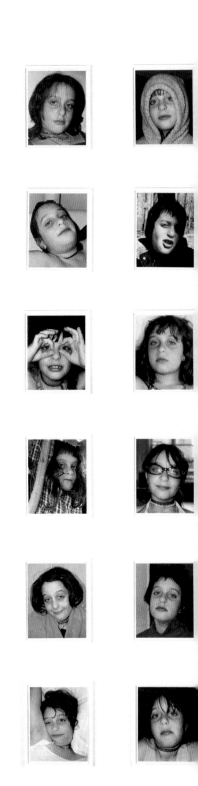

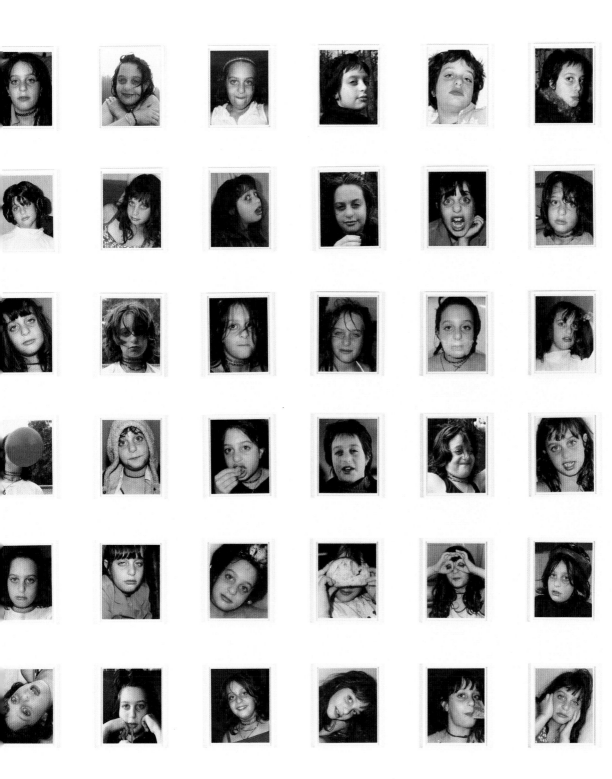

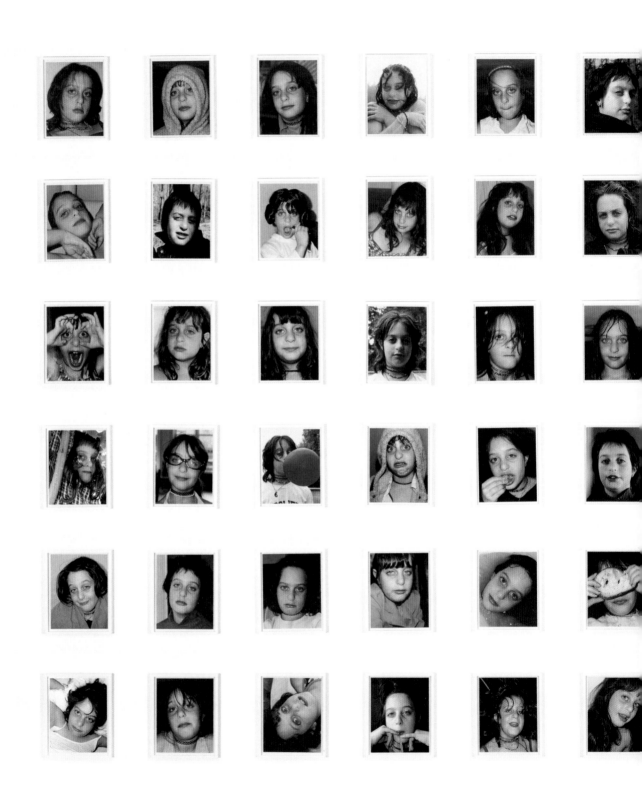

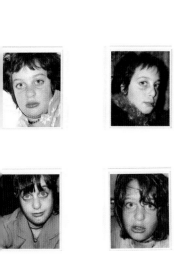

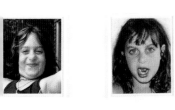
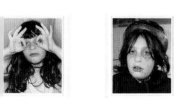
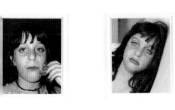

Cabinet of 2001. A clown performing thirty-six expressions.

36 framed C prints (33 x 33 inches / 84 x 84 cm). Installed as a grid: Overall dimensions: 11 x 24.75 feet / 335 x 754 cm.

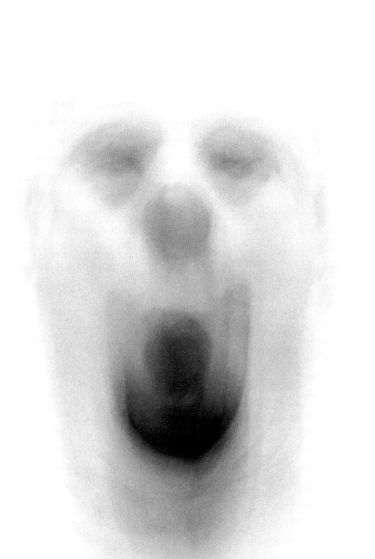

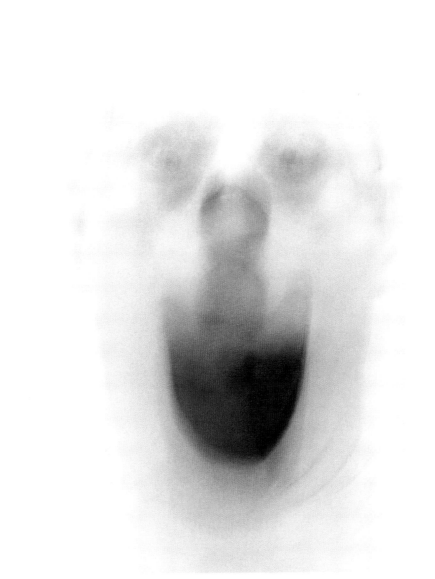

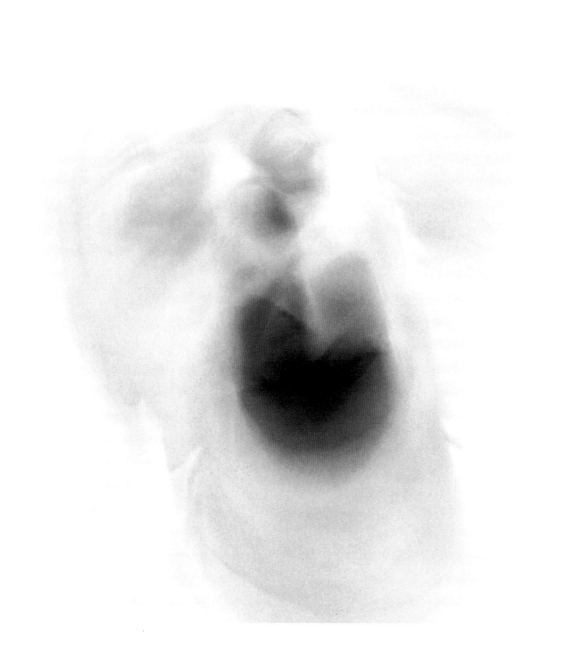

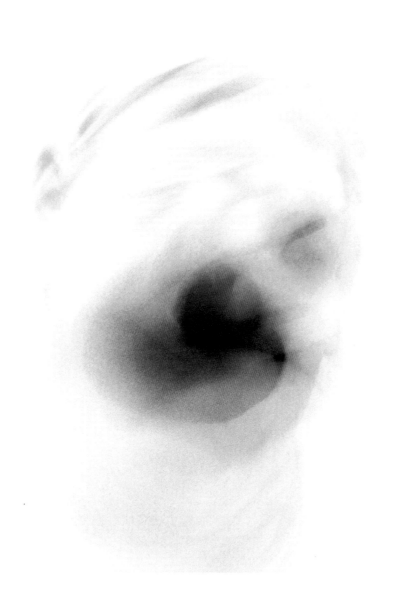

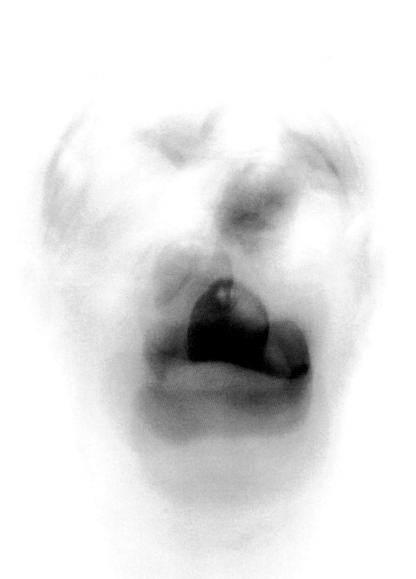

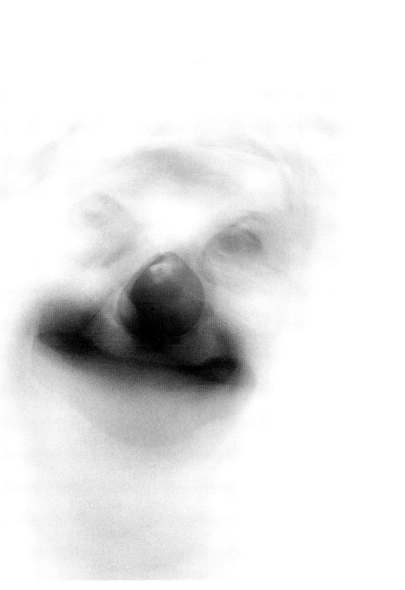

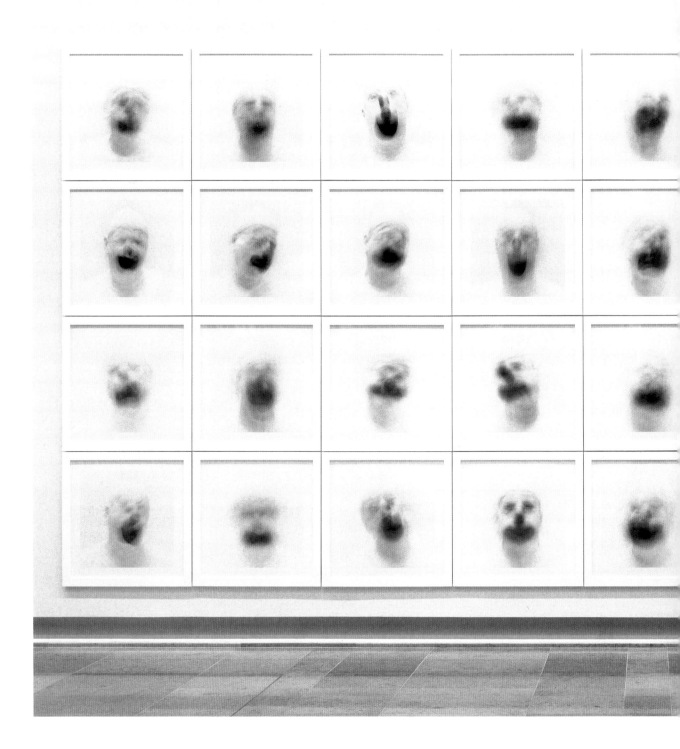

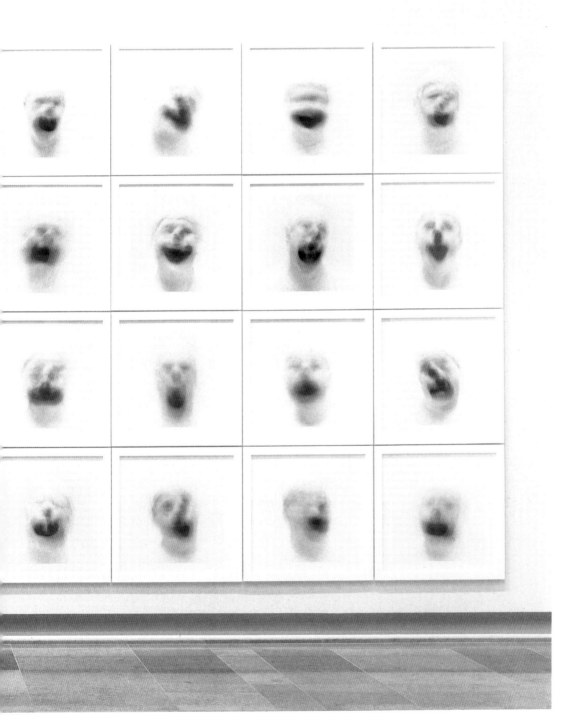

Index Cixous (Cix Pax) 2005. Hélène Cixous defining language.

A paperback book, 120 pages, 15 color and 65 tritone reproductions; 5 1/2 x 8 1/2 inches / 14.5 x 20.5 cm. |

Cix Pax, A special edition of 100 with slipcase and signed photograph. Steidl Verlag, Göttingen, Germany.

Index Cixous
CIX PAX

RONI HORN

CIX PAX

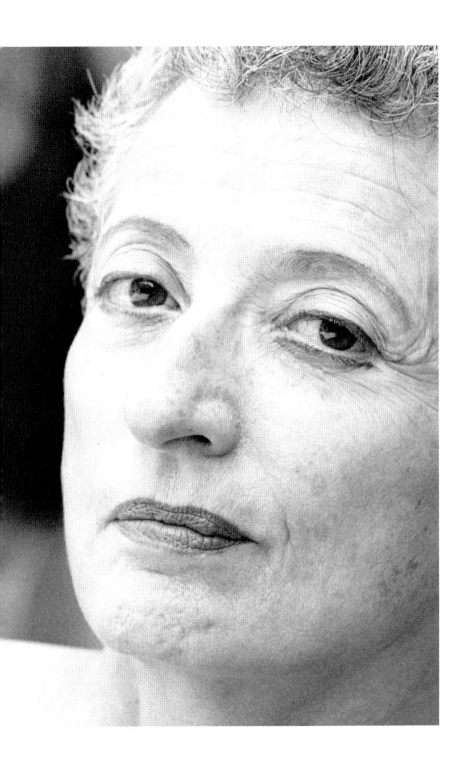

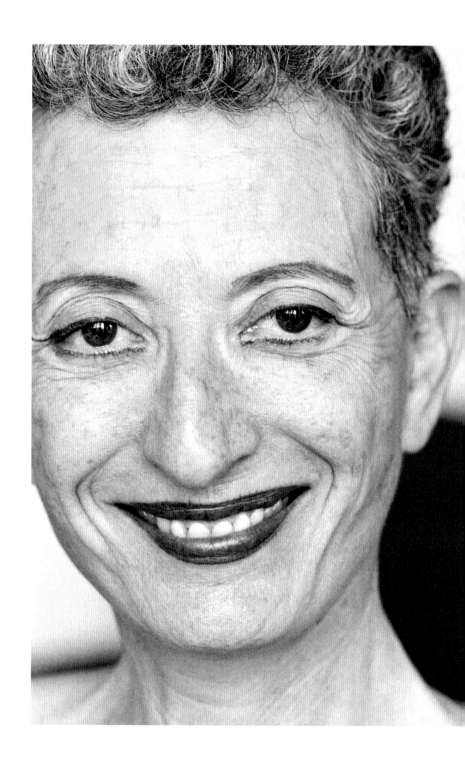

Portrait of an Image 2005. Isabelle Huppert impersonating herself in her film roles.

100 framed C prints in 20 sequences of 5 images each. Installed as a continuous horizon on the four walls of a room.

12.5 x 15 inches / 31.75 x 38 cm, each.

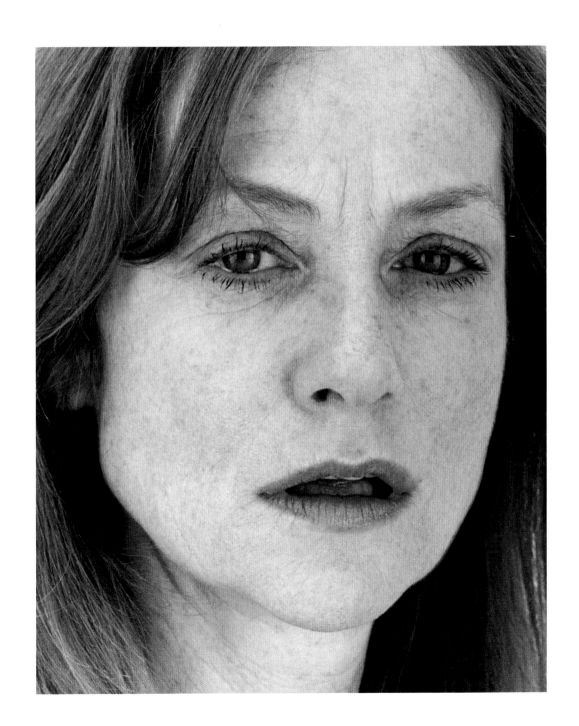

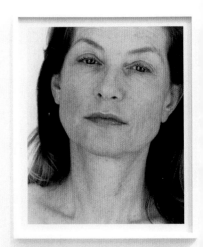

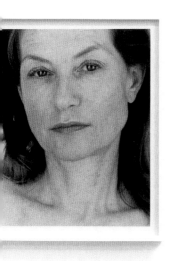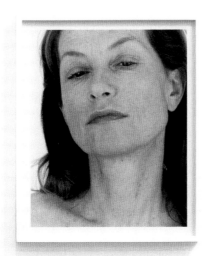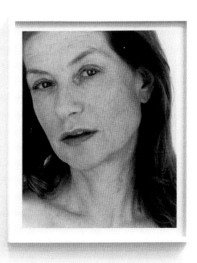

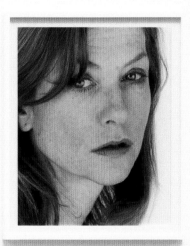

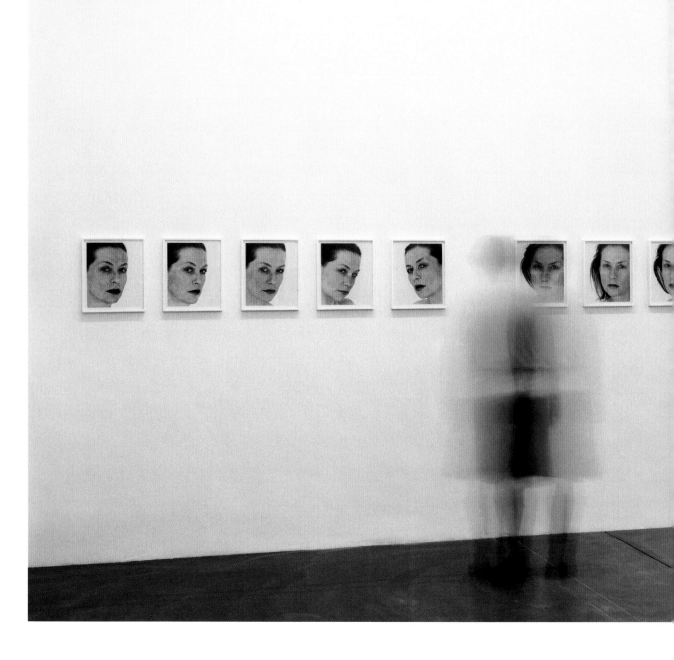

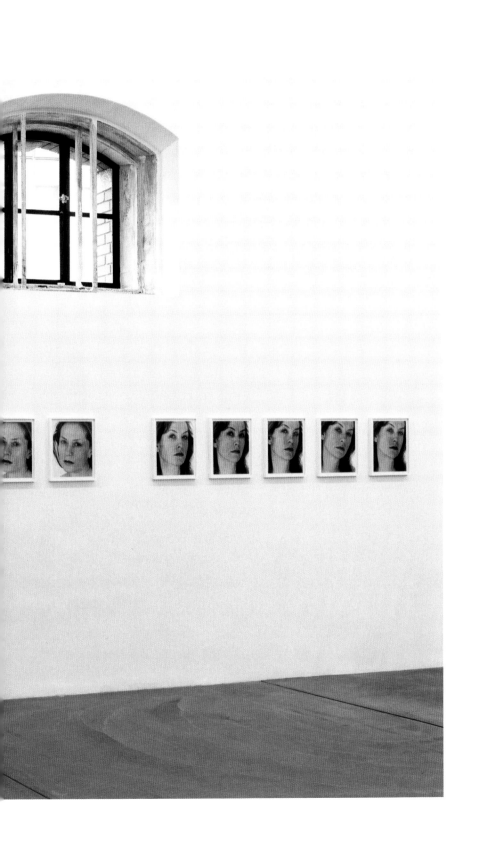

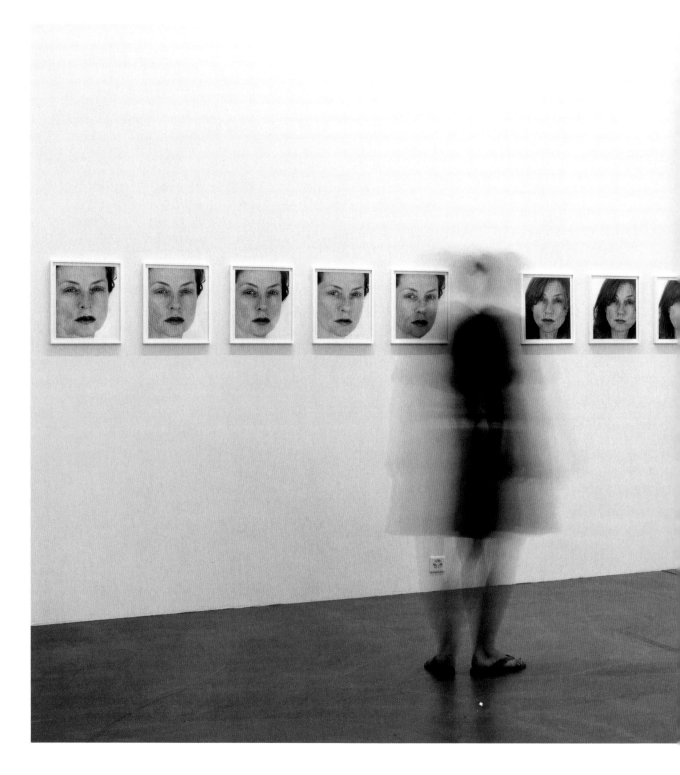

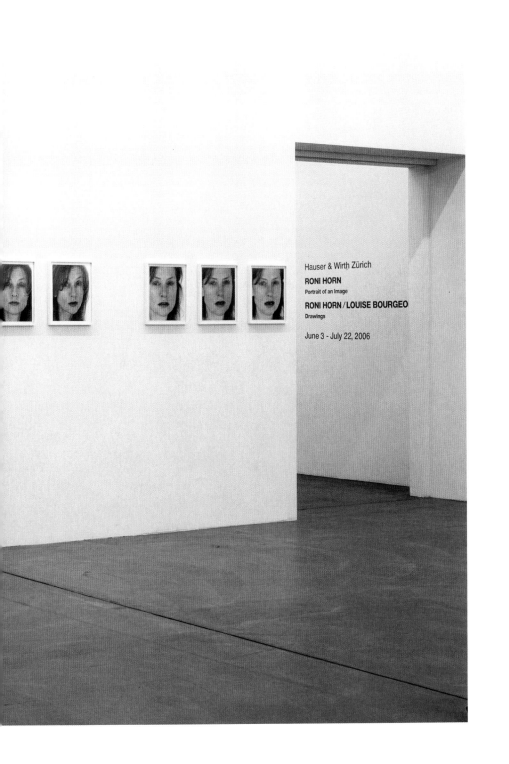

Hauser & Wirth Zürich

RONI HORN
Portrait of an Image

RONI HORN / LOUISE BOURGEO
Drawings

June 3 - July 22, 2006

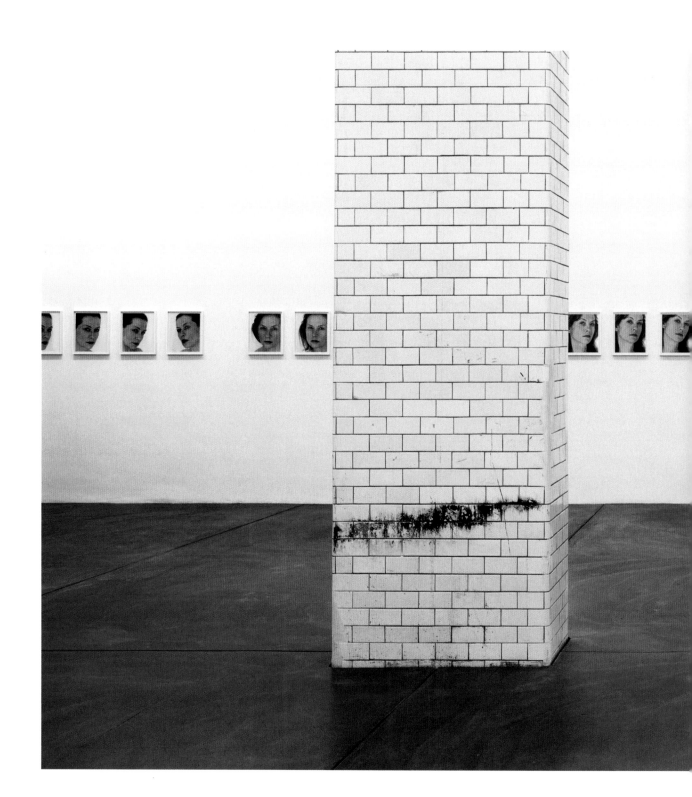

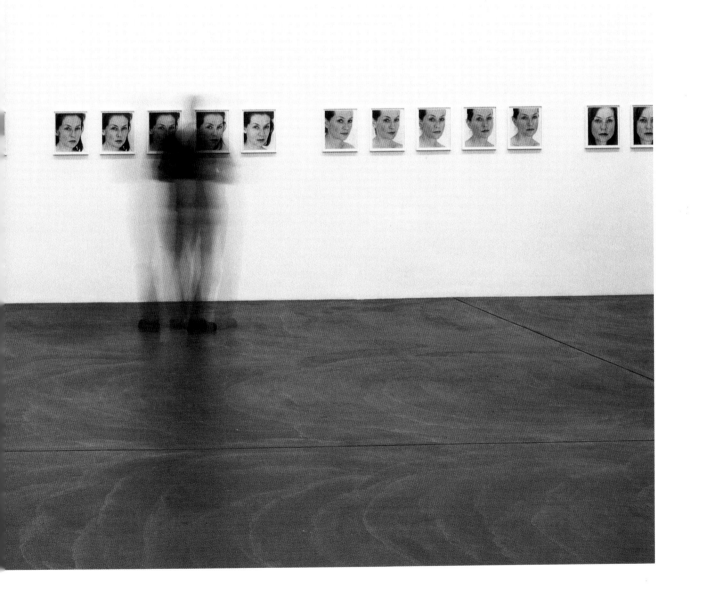

Weather Reports You 2007. A collective self-portrait— talking about the weather.

Paperback book: 196 pages, 76 color reproductions. 5 1/2 x 8 inches / 14.5 x 20.5 cm. A project of VATNASAFN/LIBRARY

OF WATER. Published separately in Icelandic and English editions by Artangel/Steidl: London and Göttingen, Germany. |

From the introduction: A COLLECTIVE SELF-PORTRAIT— We took oral reports on location that were then transcribed, edited

and translated. Word of mouth directed us from one participant to the next. For this initial production we limited ourselves

to the community of Stykkishólmur, Iceland. The 76 reports included here were collected throughout 2005 and 2006. The

accompanying snapshots were taken at the time and place of each interview. This publication initiates an archive of weather

reports that will be collected and maintained on the VATNASAFN/LIBRARY OF WATER website (www.libraryofwater.is).

Weather Reports You

Roni Horn

A project of VATNASAFN / LIBRARY OF WATER

STYKKISHÓLMUR, ICELAND

Oddný Ólafsdóttir
Born 1920, Vopnafjörður
Housewife, retired secretary

One of my first memories of when I was a girl is from Vopnafjörður. I would have been five or six years old. There was a children's Christmas party at Mikligarður, it was always held between Christmas and New Year, we girls were supposed to go and the weather wasn't fit to let a dog out. There was a lot of speculation about how to get us out there. My parents were going too and we planned to struggle along, hanging on to each other. A man called Sali who worked for us was supposed to take us girls. I remember being put on Sali's shoulders and tied down, just fixed in place, with a scarf and the like, Dad was so clever at wrapping things up and he put a scarf under Sali's arms and my arms, I can't remember how now except I sat there on Sali's shoulders and couldn't budge. Then he had to hold my sisters Ella and Magga by the hand on either side. And I remember the weather was so appalling, a snowstorm, that I always thought I was falling off and kept shouting: I'm falling, I'm falling. No, you won't fall off, Sali said, there, there, just hold onto my head, and I gripped his forehead. It was what you

call a wild blizzard, like the worst weather that ever comes. We weren't long getting there, it's just a tiny slope and we got up it and had lots of fun at the party, dancing round the Christmas tree. Then when we went home, thank God the weather had died down a bit, it wasn't as awful, but still bad. I walked then though, I wasn't on his shoulders. We held onto each other. Yes, my first childhood memory is a storm.

There were often winters when it snowed a lot and we made igloos near our house. Took spades and sticks and dug our way into the snowdrifts. It was no small amount of snow you had to carry out to make a decent igloo. We'd work on it for half the day, lots of us. We had more than one entrance, maybe three, and passages between the igloos. We got candles from my mother and lit them inside the igloos which made an icy coating on the ceiling and it stayed warm for a little while. Then we sat there and sang or told stories and felt just like being in a fairy tale. Sometimes the igloos managed to stay up for a day or two but they often blew away during the night. But the more snow the better. We also went sledging a lot, slid the whole way down from the church, that's the only decent slope in Vopnafjörður.

Recently it seems the winters aren't so harsh, they're milder now. And the climate's more even, not so much difference between spring and winter as there was. The winter was often so harsh, wild blizzards day after day and much colder. But particularly good summers came along too. I remember the summer of 1939, that was a particularly bright and sunny summer, Ella and I were in Mývatnssveit. But there were bad summers too. The difference is that now those good hot summers seldom come like they used to. But you can say one thing about the weather as it was then and still is, that in Iceland it's like nowhere else, you can never trust it.

The weather's neither bad nor good
hardly cold, not hot, not cool
It's neither dry nor wet, you could
say it's nothing much at all.

Margrét Ásgeirsdóttir
Born 1955, Djúpavogur
Postmaster

I started working for the post in Hveragerði when I was twelve.
Once I was delivering the mail in a big snowstorm and blizzard
and I took a shortcut in the village. I was so tired, I'd almost
finished and I thought to myself, I'll just have a quick lie
down here. And I fell asleep. Then I woke up with a bulldozer
clearing the snow close by and it had drifted right over me.
That's how people freeze to death, but I woke up. Afterwards
I started thinking about what would have happened if I'd been
somewhere else with no traffic. My father told me that that was
one thing you must never do. But walking in a snowstorm, you
just feel tiredness coming on and oh!, it's so nice just to lie down
in the soft snow.

Jón Magnússon
Born 1926, Eskifjörður
Retired district commissioner for Stykkishólmur

I hear the weather the moment I wake up in bed. In Eskifjörður in 1949 was the best weather in the world, the best weather in Iceland up to this day. It was so sunny. I fell asleep and woke up with the sun at my window. That was good weather for haymaking, dry and pleasant. I refused to go to bed at night, I slept in my clothes to be able to get out into that weather as fast as possible in the mornings. I would leap out of bed fully clothed and run down the stairs and out through the door, and the whole village opened up in front of me.

Any weather whatever is always good. But there was often terribly strong weather there, when roofs were blown away and windows got broken. I remember one gusty time when something remarkable happened. A boat was in the slipway with its prow facing land. In one of the gusts it lifted into the air, turned 180 degrees and dropped back down in the same place. Everyone

thought that was remarkable, because no human force could have lifted up the boat and turned it round. But I missed it. I was asleep and when I came downstairs my father was pacing the floor in the living room and constantly looking out of the windows. I looked out and saw the sky was a mass of roofing and other stuff flying about, and that sight made a great impression on me. We heard about the boat later that day and I was annoyed at missing it soar up and spin round in the sky.

Ingibjörg Árnadóttir
Born 1923, Grundarfjörður
Housewife, handicraft artisan

If the weather's bad it has a nasty effect on me. My husband
was a fisherman for most of his life and so were my brothers,
everything's been connected with the sea and naturally that
causes worry about the weather, especially if it's windy, a gale.
Once the roof was blown off the house I was raised in, this
was in 1931. Since then I've always had a fear of the weather,
it haunts me if it gets windy or something like that. The house
had to be rebuilt. It was a little timber house and Mum and
Dad lived there with their six children, grandma and granddad
were there too with their daughter and son-in-law. Dad wasn't
at home and I remember that while all this was going on, Mum
had to go outside and this young man who lived at the other end
joined in to help them hold the house down. That moved me so
deeply that I'll never forget it. In the meanwhile a windowpane
broke on our side of the house and as a kid of nine I had to stuff
a quilt into the hole in the window to keep it in place until they

came and could board it up. Since then I've always been afraid of gales. Dad came from Stykkishólmur with two men who lived out there and came back to an empty house, no one at home. We were taken to the nearest house, called Fagurhóll, which was the closest place – everything was buried in snow and we had to walk there.

Another time my old Dad was at sea, I was a child although I was older then, I think I was eleven or twelve years old. The boat he was on went missing and nothing was heard from them for two days and nights. We had no idea about how they'd fared, and then they turned up. This was in Grundarfjörður. They just had to wait for the weather to die down, found a sheltered cove but couldn't let anyone know about them, there wasn't radio in those days or anything like that.

I can't say the weather's changed my life. No, not like that, but one of my brothers drowned, it wasn't so many years ago. The boat he was on went missing.

Elva Rún Óðinsdóttir
Born 1989, Stykkishólmur
Fish factory worker

I can't recall any serious weather here. No, I don't think there's anything. I don't think so. But Jesus, when I got confirmed, the weather was crazy then and I had to put a bag over my head to keep my hairdo in place, and of course it blew away. There was so much wind that I had to fight my way to church. That, for instance.

Guðmundur Lárusson
Born 1945, Stykkishólmur
Member of the Marine Accident Investigation Board, former skipper

I don't suffer midwinter depression from the lack of light, that's doubtless been bred out of me the way they can breed anything you care to mention out of people, as happens in nature. I might not be a barrel of laughs in the winter but I don't get sad either. Still, I always keep an ear to the weather. Summer weather makes me feel good, when it's warm and sunny. Calm weather at sea is extremely pleasant, when you almost need to keep your eyes closed because of the refraction of the light. But that damn fog is the worst because you don't know where you are. You can't locate yourself in the fog.

Everyone has to fear nature a bit. It can be terrible sometimes. But like everyone else, you don't let it upset you just because the weather's unpleasant. It depends so much where you are. The wind's so much stronger when you're standing upright than when you're lying down in the grass, and the difference

is noticeable at sea. If you swim in the sea in a storm you can't feel the weather, because there's no wind, but the moment you come up out of the sea you feel it. A boat I was on sank once. I was just a youngster, I'd just started my life, and I found out that the same law applies at sea and out in the meadow when you lie down in the grass: the wind largely disappears down in the troughs of the waves. But it's cold to swim in the sea. It was nasty weather, but not a tempest. A storm. A wave broke over the boat and it capsized. So there was nothing for it but to tread water and get swamped by all the waves. It was a very thick ocean wave, heavy seas, and I didn't know if I'd come back up on the wave I went down on. Two of the crew died, and one was a very good swimmer. He probably got trapped under a wave and couldn't get back up.

That experience haunted me for decades. But I went straight back to sea. Soon afterwards we lost a man overboard – I was a young mate and the boat was cruising. It was one of those old herring boats with a ladder up the side of the fishing gear, which was naturally slippery from fish oil or the wet, and he lost his footing and fell overboard. He probably hit his head on the gunwale and knocked himself out because I saw him when I turned round and I went after him. You should never do that, never do anything without thinking, because I only just made it back aboard and was in a much worse state than after swimming to land the month before. And that was in summer, the previous time it had still been winter. I went after him without any means of help, although they tried to pass me a lifeline, which in fact was all twisted. It would probably have been better to tie it round me before I went, because when you're in the sea you can't see a thing. You can't see far, your eye-level is virtually zero and I never saw the man after that. Even though he definitely wasn't far away from me.

The weather's like that. If you don't fight it, you become one with it and vanish. You cease to exist if you don't show resistance and cunning. Some people are said to have an eye for the

weather but that goes hand in hand with having an eye for life in general. They're doubtless better hunters and fishermen and notice more things in nature. Some dream the future and the weather, but I don't. I was sent to my grandfather at an early age, he was an island farmer and I was his handyman for a long time, I spent all the summers with him on Flatey, hunting seals and other tasks. He used sails even though boats had been motorised for fifty years. He always used sails to save petrol when there was a tailwind. And then I got to know nature and started to pay attention to things I'd never noticed.

I don't think the weather's changed. What has changed is the ships. I started as a cook and there was no sink, we just washed up in a bucket. And for a seasick cook to be peeling potatoes in rolling seas with potatoes rolling all around him! Eating prunes was good, it was so good to throw them up! But there are just as many heavy storms today as twenty years ago.

Anna Sigríður Gunnarsdóttir
Born 1960, Reykjavík
Nurse at St. Francis Hospital

Several years ago I was very depressive, I often used to think then that you don't know which came first, the chicken or the egg, if and how the weather affected my depression, for better or for worse. And I remember at that time I was shut in here by myself a lot, I shut myself away and there was an incredible amount of salty northerly storms. No snow on the streets but brine and seawater spraying everything so all the windows turn grey and the asphalt jet black although it is just dry. If you pull yourself together and go outdoors to scrape the salt off it gets a little brighter, you feel a little brighter. If there'd been warm sunny weather I wouldn't have needed to go out and scrape the windows clean! But I doubt I would have been so depressed in warm sunny weather. But there's also the question if I felt the weather worse because I was unbalanced.

I go through mood swings and if I'm full of self-confidence then the stormy winds are just brilliant, and the rain and the gloom and everything that would stick in my head if I was feeling down.

If I'm in my stride I feel good in a snowstorm. For example, the best thing I know is going swimming in drifting snow and blizzards. Swimming like mad and then getting into the hot pot at the swimming pool. Feeling those extremes, the heat and the cold. Then maybe one day I wake up and there's that sort of weather and it's repellent. It's difficult to work out this interplay of mood and weather.

I adore the weather that they call a light breeze on the weather reports, it refers to the rippling sea and is next door to calm. It's brilliant to go rowing then. Calm weather. That's precisely the description of a good state of mind. That calmness. And fog, even. But calm. Wild weather's a challenge too if you're in that frame of mind.

Egill Egilsson
Born 1991, Stykkishólmur
Student

The best weather is the weather I can play basketball in. The worst weather is when I can't play basketball, I think.

Hólmfríður Hauksdóttir
Born 1938, Arnarstaðir
Farmer (Arnarstaðir)

The most memorable weather is the summers when the grass is growing and the meadows and pastures are turning green. I think it's most important and best for farmers to have good weather at lambing time and haymaking time. Farmers need good weather in lambing time when the sheep come out with their little lambs, it shouldn't be cold then, and during haymaking when you try to get good hay, because the better and drier the weather then, the better the fodder is for the animals.

o10800463

Jóhann Pétursson
Born 1918, Stykkishólmur. Died 2006.
Retired lighthouse keeper at Hornbjarg

One winter when I was little there was so much snow that my father had to go out through the upper floor window to dig his way down to the door. Imagine that snowfall! That's unknown these days.

When I was at the Hornbjarg lighthouse everything revolved around the weather. I could almost say that I shifted my position in my chair according to the weather. I could feel it all. The weather and weather measurements. I had to record the weather at three-hour intervals round the clock for twenty-five years.

I had to go up onto the mountain every single day, whatever the weather. So I ought to have some definition of the changeability of the weather. But I'm such a blockhead. It's a fact that even if you do something daily that has an effect on you, it's as if it never sticks in your mind as a special phenomenon. Unless you're hit over the head! But sometimes I feel my whole life was spent more or less in peril.

0108QO463

This publication | Accompanies the exhibition *A Kind of You: 6 Portraits by Roni Horn* at the Australian Centre for Contemporary Art, Melbourne, August 11 – September 30 2007.

ACCA Acknowledgements | The Australian Centre for Contemporary Art (ACCA) thank Roni Horn for her vision and commitment to realising this exhibition and publication; Cornelia Providoli, Isabelle von Meyenburg and Ulrike Gast at Hauser & Wirth Zürich for their invaluable support and for the loan of works for the exhibition; Anna MacDonald at ACCA; and Gregor Muir at Hauser & Wirth London.

We are indebted to Gerhard Steidl for his offer to produce and publish this exhibition catalogue. Our special thanks to Hélène Cixous for her written contribution; and to Eric Prenowitz for the translation of the text.

Thank you to the dedicated ACCA installation team, in particular Ned Needham and Jess Johnson. Our thanks also to Fundació la Caixa and De Pont Foundation for Contemporary Art for the loan of work for this exhibition.

—*Juliana Engberg, Commissioning Curator & Gabrielle de Vietri, Coordinating Curator*

Cover photograph and those on pages 1, 3, 6, and 10 | Taken for this publication. The assistance of Margrét H. Blöndal is gratefully acknowledged.

All photographs | Courtesy of Hauser & Wirth Zürich London and the artist. Photo credits: pages 16-17, 38-41, 68-73: Bill Jacobson; pages 18-27, 74-79: A. Burger; pages 50-5: Nic Tenwiggenhorn.

Translation | of *Portrait of Portraits* from the French by Eric Prenowitz.

Publisher | Steidl, Göttingen, Germany. © for text Hélène Cixous, 2007. Copyright © 2007 for *A Kind of You,* book design: Roni Horn. © 2007 for this edition: Steidl and Roni Horn. For other books by Roni Horn go to www.steidlville.com

Production and printing | Steidl, Düstere Strasse 4, D-37073 Göttingen, E-mail: mail@steidl.de, www. steidl.de. All rights reserved. No part of this book may be reproduced without the written permission of the publisher or the artist. ISBN 978-3-86521-583-3. Printed in Germany.